THE NON-DRUG EUROPEAN SECRET TO
HEALING SPORTS INJURIES NATURALLY

How the same systemic oral enzyme
remedy used by Europe's Greatest
Olympic champions can help you
to heal sports injuries naturally.

by
Michael Loes, M.D.(H.)
and David Steinman, M.A.

Disclaimer: The material in this presentation is for informational purposes only and not intended for the treatment or diagnosis of individual disease. Please, visit a qualified medical or other health professional for specifically diagnosing any ailments mentioned or discussed in detail in this material.

This information is presented by independent medical experts whose sources of information include scientific studies from the world's medical and scientific literature, doctors' patient and other clinical and anecdotal reports.

ISBN 1-893910-03-2

First Printing, May 1999

Published by Freedom Press
1801 Chart Trail
Topanga, CA 90290

Bulk Orders Available: (310) 455-2995 / (310) 455-8952

E-mail: sales@freedompressonline.com

4 The Non-drug European Secret to
Sports Greatness and **Olympic Gold**

7 Achieving **Sports Excellence** Without Drugs

9 Elite Athletes Who Use the **Wobenzyme®N** Enzyme System to Achieve **Sports Greatness**

13 Systemic Oral Enzymes

15 Enzymes, the **Healing Response** and So Much More

18 CyberAthlete **Chat Room**

21 Health Problems with Non-steroidal Anti-inflammatory Drugs

24 How **Common Pain Drugs** Inhibit Healing

27 Types of **Sports Injuries**

30 How Systemic Oral Enzymes **Accelerate Healing** of Sports Injuries

33 Studies that Validate **Enzymes** for **Sports Injuries**

42 A **Final Word** to All Athletes

45 How to **Purchase** Wobenzym®N

46 References

48 About the **Authors**

CyberAthlete
Website
Menu

The Non-drug European Secret to
Sports Greatness
and Olympic Gold

There is a secret all-natural supplement that many of Europe's greatest champions and world record holders swear by. You've probably never heard of it, but, if you aspire to sports greatness and Olympic gold—or, if your goal is to simply achieve your own personal best—you need this supplement—and the information in this book that will be revealed to the American public for the first time.

This supplement is not only medically validated in the world's leading medical journals—but proven on the field of action where all that counts is guts, blood, sweat, tears, and excellence.

To focus on one country—the Czech Republic—this all-natural supplement is one of the keys to success for athletes such as world champion record holders Jan Zelezny in the javelin and Daniela Bartová in the pole vault. It is the key training aid used by Olympic decathlete champion Robert Zmelik, as well as by fellow world champion Tomás Dvoräk; and triple jump world champion Šarka Kaspárková. In professional tennis, Martina Hingis, who uses this all-natural performance and training aid, has been ranked number one or two in the Women's Tennis Association.

Moving elsewhere in the world, Ukraine boxer Oleg Kiriukhin, a bronze medalist in the 1996 Olympic Games in Atlanta, uses this formula daily to aid his training and heal his body faster.

Closer to home, the formula is used by European hockey stars Jaromir Jagr of the National Hockey League's Pittsburgh Penguins; Zikamind Pullfy of the New York Islanders; and Peter Bondra of the Washington Capitals.

The list could go on and on.

Perhaps one other story will illustrate the importance of this supplement to athletic performance and training. It has long been known that within the

entire former Soviet bloc, the best sport scientists were found in East Germany. After all, this tiny, racially and ethnically homogenous nation with its limited gene pool and population of only about seventeen million dominated so many Olympic events from the 1960s through the 1980s.

The East German sports scientists and doctors, it was well known, were highly advanced in developing performance and training regimens, including methods for the deplorable masking of the doping of their champion athletes. The East Germans were, in fact, the first country to systematically use androsteinedione and other banned androgens.

In 1984, when the Olympic Games came to the Balkans for the first time, although the Soviet Union would finish the Sarajevo Games with the most medals, 25, it was the East Germans who would strike gold the most, with individuals and teams finishing first in ski jumping, women's figure skating, women's speedskating, women's luge, and the two-man and four-man bobsled—for a total of nine gold medals.

the non-drug European secret to sports greatness and Olympic gold

Christa Rothenburger (East Germany) set an Olympic record in her gold medal performance in the women's 500 meter speedskating competition. Second place finisher Karin Enke, also from East Germany, captured the gold in both the 1,000 and 1,500 meter race. Andrea Schone completed the East German sweep of the women's speedskating events with a gold medal in the 3,000 meters. East German women also won 11 of 13 gold medals in swimming at both the 1976 and 1980 Olympics.

Unfortunately, recent studies have revealed that between 6,000 and 10,000 athletes were covered by a systematic doping program that operated in the former Communist country. And, yet, there were also many advances within the East German sport training regimen that were highly acceptable aids to performance. Even with doping, the East German athletes still needed to be able to recover more quickly from their training as well as injuries.

This is where our natural supplement comes into play. For a very long time, Mucos Pharma GmbH, the German manufacturer of systemic oral enzyme preparations, was receiving orders for large amounts of their famous

enzyme formula, Wobenzym® N, from various agents in Vienna and other European cities. Of course, as the orders came in, hundreds of thousands of Wobenzym N tablets would be promptly shipped, it was thought, to be used in medical settings such as hospitals and clinics. Little did Mucos Pharma realize how their premiere enzyme formula was really being used . . .

In 1989, the Berlin Wall came down. A divided Germany was re-united. Now that travel throughout Germany was once again free, Mucos Pharma scientists visited hospitals in the former East Germany, expecting to see large amounts of Wobenzym N—yet, they saw none! The mystery remained for several more years.

Then, one night in the mid-1990s scientists from Mucos Pharma GmbH were at a dinner where one of the guests was the former head of the East German Physical Culture Institute. It was at this dinner party, during the social hour, that a former East German administrator admitted that it had been they who were purchasing the Wobenzym N tablets through various middlemen, smuggling it into East Germany. He conceded that the formula allowd their athletes to train harder and longer. Their athletes used Wobenzym N—a completely legal substance—in very large amounts to lower the effects of training and especially to safely and naturally stave off inflammation, redness and swelling.

The East German official explained that whenever athletes train, they will always incur microtrauma to the tendons and ligaments and place stress on the joint matrix and other tissues. Wobenzym N was the perfect answer to maintain healthy joint function and range of motion. The illegal androgens were, of course, important, but perfectly useless to an athlete beset by injury. If the East German athletes could moderate their inflammation, they could maintain full strength and range of motion. He also mentioned unpublished data that Wobenzym N was in itself a perfectly natural and highly effective anabolic aid for building strength, muscle, and endurance. Finally, the mystery behind the huge orders for Wobenzym N was revealed. But now, the task at hand was even more challenging: inform the world of a legal, acceptable, ethical, safe and proven performance aid that could heal injuries naturally.

The Non-drug European Secret to

Welcome to the **winning combination** for today's **cyberAge athletes**

Americans are more aware than ever before of the positive effects of exercise and proper nutrition. The drastic increase of recreational sports and fitness during the last quarter century is a lifestyle revolution.

Exercise is one of the most important things people can do to create great physical and mental health. Exercise not only helps persons to lose weight, control food cravings, reduce the risk of diabetes, heart and circulatory disease and cancer. Exercise also helps the body to create feel-good *endorphins*, tiny peptides comprised of amino acids that resemble opiates and that are released by the brain in response to stress or trauma, reacting with the brain's opiate receptors to reduce the sensation of pain; fortunately, their effects carry over long after exercise is finished, fostering a positive mental outlook on life.

This fitness boom, however, has a downside: sports injuries are becoming increasingly prevalent as more and more health conscious people start to exercise daily. What's more, too many athletes at all levels are turning to drugs, such as over-the-counter or prescription medications as well as banned and illegal substances, to overcome their injuries in an attempt to excel at their athletic endeavors. Every year, millions of athletes of all ages suffer debilitating injuries. They usually end up taking pain killers such as aspirin or other over-the-counter preparations known as non-steroidal anti-inflammatory drugs. These formulas may quench the pain, but they do nothing to initiate the healing process and their long-term use poses significant complications. We are here to say that today's new breed of championship athlete can succeed without drugs, and that while we are one-hundred percent for creating champions—we are equally opposed to the indiscriminate and

proliferating use of street and even legal, yet dangerous medical drugs in conjunction with sports, particularly for overcoming injuries and hastening recovery time in cases where safe, natural alternatives are available.

We have a better way to heal sport injuries—a secret that every athlete needs to know about and that the great European champions have known about for some time: systemic oral enzymes.

*Elite athletes who use
the Wobenzym®N enzyme system
to achieve sports greatness*

Systemic Oral Enzymes
and sports injuries: worth their
weight in Olympic Gold

HERMANN MAIER

Shiga Kogen, Japan. Picabo Street singing "The Star-Spangled Banner" with a gold medal around her neck. Alberto Tomba lying in the snow, grabbing his sore back. Katja Seizinger leaping off the victory stand. These are some of the images that we will long remember when we think back on the 1998 Winter Olympic Games. And then there was Austrian alpine skier Hermann Maier.

Despite days of snow, rain, fog and wind that caused maddening delays and scheduling nightmares, the Alpine skiing events provided some of the most compelling images of the Nagano Games.

None, though, could match the horrifying sight of Maier flying sideways through the air and crashing through two safety nets. The press and critics were certain his Olympic gold medal quest ended with that terrifying crash. Yet, Maier went on to return from the bruises, swelling, redness, tenderness and acute pain, both physical and mental, of his awful tumble to win two gold medals within the next six days. Maier's crash indeed provided one of the lasting images from the Games.

But what few know about Hermann Maier is that, besides his intense competitor's drive, the Austrian champion was using a very special, scientifically formulated enzyme formula. This formula, now available in the United States, is the leading sports injury medicine in the world. It is only just now being discovered by our American athletes. It was this formula that Maier's own doctor has publicly stated helped his star patient overcome his terrible

injuries and aided tremendously in stimulating the healing process that enabled him to return to action quickly.

According to Maier's doctor, his daily use of Wobenzym®N systemic oral enzymes, immediately following and long before the accident, was, in fact, one of the principal reasons he suffered no lasting serious injury during his terrible free fall down the rugged mountainous slope. In fact, the Austrian and German Winter Olympic teams ordered more than one million pills of this natural medicine for the 1998 Olympics. Why? Because they wanted to win, and systemic oral enzymes provided them with a drug-free edge over the competition.

BOBBI GALE BENSMAN

If you want to talk about a tough sport that is sure to make for sore and inflamed muscles, that sport would have to be rock climbing and bouldering. It's man vs. rock. Or, in the case of Bobbi Gale Bensman, *woman* vs. rock.

Nationally ranked among the top three rock climbers from 1987 to 1995 and a winner of more than 20 national competitions, Bensman knows all about sports injuries and soreness. She swears by systemic oral enzymes.

"Being a competitive and intense athlete, I think that systemic oral enzymes are essential to take daily," she says. "Systemic oral enzymes are remarkable for enhancing my energy levels and healing from injuries. When I am run down or have sprains, tendon or joint problems, I'll increase my dosage and come back even quicker."

"I just took a trip to Australia in April and May," she continues. "I was hiking down a really steep hill and twisted my ankle. I had run out of my enzymes and the injury lasted for a month. When I arrived home, the first thing I did was to start taking five tablets on an empty stomach two to three times a day. Once I was using enzymes, the swelling and soreness disappeared within a few days. Let me tell you from my own personal experience: enzymes work better than ibuprofen and without side effects, which is important to a competitive athlete like me.

The Non-drug European Secret to

"But there are a lot of other reasons I take systemic oral enzymes daily. The formula is great for digestion and enhancing my resistance to colds and the flu. Systemic oral enzymes are just a great product all around for making your body work better."

STEFI GRAF

On June 12, 1997, in an attempt to quell growing expectations of a quick recovery after undergoing knee surgery in Vienna, tennis star Stefi Graf announced to the world press that she would certainly miss Wimbledon and the U.S. Open. Even the German Sunday newspaper *Welt Am Sonntag* hinted that there was no guarantee she would resume her career following her knee operation in Vienna.

But the former world number one tennis player and twenty-one times Grand Slam champion had a secret tool to help her recover after the two-hour operation on her left knee at an undisclosed hospital in the Austrian capital. Her secret? A skilled surgeon and, as her own personal physician publicly stated, many of his sports patients regularly use systemic oral enzymes. Less than a year later, Graf was competing again—and winning.

Systemic Oral Enzymes and sports injuries: worth their weight in **Olympic Gold**

Throughout the world today, athletes, from weekend warriors to Olympic gold medalists, have discovered the secret of systemic oral enzymes. German figure skating Olympian Katarina Witt and tennis stars Boris Becker and Stefi Graf, to name a few, are thought to use the systemic oral enzyme system we will tell you about, but there are many more athletes who are also champions in sports as diverse as track and field, hockey, skiing, boxing, karate, soccer and American football, who are also using systemic oral enzymes to excel and reach their very peak of fitness and competitiveness.

Do these championship athletes and weekend warriors know something about keeping healthy and avoiding sports injuries that other injury-riddled athletes have yet to learn?

What is this secret, then? What are these special enzymes? Are they approved for use by international sport governing bodies? Are they

proven with medical studies? What can they do for elite athletes? What can they do to help weekend warriors? Can they benefit children and high school athletes? How can they help *you*, whether you are an elite athlete, competing in the masters class or a collegiate, high school or junior level athlete? What if you are simply a walker or work-out daily on your treadmill and want to stay healthy and in shape? Can systemic oral enzymes help you to stay healthy and fit without requiring potentially toxic prescription medications or other potentially dangerous drugs?

systemic oral enzymes
Come with us on the healing journey of your life

We have a fantastic story to tell. Come with us and get ready for a story that will help to make you a healthier, stronger champion. We will tell you about a type of natural, totally safe and proven natural medicine called systemic oral enzymes that can help you to overcome many of the most common maladies and conditions afflicting athletes today. It is like no other story that has been told before, and systemic oral enzymes are like no other medicine available anywhere in the world. If you are an elite athlete, weekend warrior, or just someone who wants to stay in shape, we believe that you will find systemic oral enzymes to be one of the healthiest, most fantastic training aids that you will ever use.

If you have ever said, "I don't want to suffer the pain of arthritis" or "I don't want to sit on the sidelines because of redness and swelling" or "I don't want to lose my ability to exercise due to muscle soreness" or "I don't know what to do about my bruising" or "I want to overcome the disabling fatigue and overuse injury syndrome of intense athletic training," or "I want to do something about my sports injury besides taking toxic pain killers," or, "I'm tired of suffering muscle tears and inflamed joints that keep me on the sidelines," then the time is right for you to start to use systemic oral enzymes.

And if you are not yet using these miracles of nature, then you are missing out on a true fountain of life.

Enzymes are the food of the future. They excel like no other medicine or food today at strengthening the body's ability to overcome the most common sports injuries. Systemic oral enzymes are probably the greatest, virtually best kept secret in sports medicine today.

When two-thousand years ago Hippocrates advised doctors of the future to, "Let food be your medicine and medicine be your food," little did he know that for athletes systemic oral enzymes fit the bill perfectly.

We make you this promise.

You'll not only learn how important enzymes are to helping the world's most competitive, elite athletes perform at their best and about how recent Olympic gold medalists have used enzymes to reach the height of triumph, but also how systemic oral enzymes might be the most powerful tool to date for treating any sports injury and improving your overall cardiovascular health, resistance to cancer, and other immune conditions such as rheumatoid arthritis.

Are you ready to step through the door with us?

THE 10-POINT SPORTS INJURY RECOVERY PROGRAM

You can turn on the amazing healing powers in your own body and initiate dramatic improvements in your health if you are suffering from sports injuries by following our comprehensive ten point program. It consists of the following elements:

- Proper diet.
- Daily use of systemic oral enzymes.
- Aerobic and conditioning exercise.
- Stretching.
- Weight loss, if necessary.
- Avoiding repetitive motion.
- Using biomechanics and ergonomics.
- Alleviating stress.
- Maintaining a positive outlook on life even in the face of adverse circumstances such as painful injuries.
- Maintaining a balanced sensible approach to training and competition and never giving up.

We're here to coax, persuade, and motivate you into action to put your quest for the ultimate in sport achievement back on track by our ten point healing program, and especially the use of drug-free systemic oral enzymes.

Enzymes, the healing response
and so much more...

Pain, along with loneliness, is perhaps the greatest fear a human being can experience. When we are slapped with it, much like a dealt hand, we would like to fold it, but can't. The terror begins, and the search for cure or meaning ensues.

Enzymes can help you to overcome the pain and fear of sports injuries. Enzymes are the ultimate holistic healing medicine.

What we are looking for here is something to convert a retreat into an advance, to turn despondency into laughter and to transcend when free fall is approaching as one would envision the canoe about to go over the falls.

Pain and its closely related underlying body condition inflammation are the pairing we need to attack, to advance upon, scale and transcend. We need to understand the relationship, so as to sabotage, subterfuge, conquer and cure. Enzymes fit perfectly into this pairing. They are the ultimate tool for the relief of pain and inflammation.

Yet even though we know a lot about this interesting area of medicine, we're learning more all of the time. The beauty of systemic oral enzymes is that these simple pills are such powerful and broad-spectrum biological response modifiers that at the same time you are treating the pain of your sports injury, you'll also be reducing your future risk for a heart attack, stroke, cancer, kidney disease, arthritis, lupus, and many other disease conditions.

In a very real and true sense, enzymes have such a broad biological response within the human body and without any significant toxicity, they actually work better than any of the current crop of pain relievers in use today, particularly for long-term chronic or intermittent acute pain.

Unfortunately, most doctors and consumers do not yet fully understand that enzymes do much more than just simply aid the body in digesting food.

They act inside the system, along with co-enzymes and catalysts, to modulate, enhance and restore health. This concept should not be new to doctors—if they've taken time to read leading international medical and scientific journals; but, unfortunately the use of enzymes appears to have been restricted to use in European countries much more attuned with natural medicine, not the United States.

It is our opinion that systemic oral enzymes offer the first long-term treatment option with proven healing and safety. This is especially true when compared to corticosteroids and less potent anti-inflammatories. It is not our position or intent to disparage other claims, and we recognize the occasional specific need for these latter agents, but for mainstream prevention and treatment of sports injuries, systemic oral enzymes make more sense and cost less cents. The toxicity of the NSAIDs and corticosteroids is well known particularly with upset stomach (epigastritis), kidney disease (interstitial nephritis), and liver damage (hepatocellular mitochondrial damage). We present this information not only as physician and educator, but as consumer advocates, hoping that your healing path will be a quick journey without wasting precious time or valuable dollars on unproved therapies. We feel that this book is especially important because it comes at a time when pharmaceutical companies, according to *The Wall Street Journal*, are likely to be launching heavy advertising campaigns for sports injury- and pain-related prescription drugs on television and other forms of mass media.[1] You, the consumer, are likely to be asking your physician for these drugs because you saw them on TV, rather than ask for systemic oral enzymes because you have searched out the data. In a mass media campaign, it is unlikely the risks will receive equal time and print size with the benefits of these new therapies. It is imperative that consumers be informed. Health knowledge is as important today as ever. By being informed, you are actually helping doctors to do their job better.

We also know that many doctors will continue to remain skeptical that a natural substance like systemic oral enzymes is effective in treating sports injuries. They will continue to argue that systemic oral enzymes have no scientific evidence because

they will not accept findings from the European clinical trials. It is very interesting that reliable knowledge stops just east of New York, according to the Food and Drug Administration.

These doctors are wrong. They are clearly not familiar with the extensive data accumulated in European trials, including their use by so many European championship athletes. Over time, they are likely to modify their opinion, especially in view of the substantial evidence that supports the healing properties of systemic oral enzymes.

Indeed, in Germany, the systemic oral enzyme preparation that we will discuss has benefits so profound, it is now the number one non-aspirin leading over-the-counter (OTC) medicine for pain and inflammation among all OTC drugs, and the ninth leading natural medicine among *all* drugs, OTC or prescribed.

Much like the post-its or even the first photocopiers, that at first were seen to be without a function, so also were systemic oral enzymes for a long time a tool looking for a new function. Yet, now, after thousands of medical studies (virtually unknown in the United States but widely published and respected throughout the rest of the world), the proper uses for enzymes have been found. One of these is for sport injuries.

enzymes, the healing response and so much more...

If taken on an empty stomach, they are well absorbed and get right into the battle of fighting, calming and even reversing the damage done to our body by the evil triplets of sports injuries: redness, inflammation, and swelling.

Some eight billion dollars is spent annually in America alone in attempts to alleviate pain and suffering related to joint tenderness and inflammation, much of this money spent on ineffective panaceas or unconventional treatments. We can do better. Now with oral systemic enzymes, we have the tools and the craftsmen to do so.

Healing Sports Injuries Naturally takes some recently acquired knowledge and uses it to help you get back to your God-given, genetic, optimal appearance and function.

Pro-consumer,
independent voices
that are on your side

Our intention here will be to present and discuss much of the available information on systemic oral enzymes. We wish to give you additional data and opinions that should result in your ability to enhance the healing response after suffering a sports injury, rebuild degenerative tissues faster and more permanently with a proven method backed by studies on thousands of athletes—and without your wasting money on unproved therapies based more on exaggeration than substantiation.

In preparation to write this book, we reviewed the results of hundreds of clinical trials and other studies on other treatments besides systemic oral enzymes. We examined medically prescribed and OTC drugs commonly used throughout America and Europe to treat sport injuries. We wanted to critically examine how systemic oral enzymes compared to these other commonly used medications. We were especially careful to look for studies in which systemic oral enzymes were compared to the commonly

CYBER INSIGHT

The NSAIDs, such as aspirin and ibuprofen, are beneficial and help to reduce swelling, heat and pain. The patient may feel better, but no rebuilding of the tissues has occurred and further degeneration may have actually occurred. We found while the most commonly recommended NSAIDs have some limited benefit in the short run, in the long run they simply cannot match up to systemic oral enzymes for either efficacy or safety.

The Non-drug European Secret to

used non-steroidal anti-inflammatory drugs including ibuprofen and diclofenac. In addition to our combined clinical, nutrition and journalistic experience spanning some forty years in sports and pain medicine, we reviewed more than 200 studies on the use of aspirin and other NSAIDs in the treatment of pain. We wanted to know what toxicity problems were most prevalent and what you, the consumer, really need to know regarding the use of these powerful pain-relieving drugs, which are part of the eight billion dollar pain reliever industry in America alone.

We found while the most commonly recommended NSAIDs have some limited benefit in the short run, in the long run they simply cannot match up to systemic oral enzymes for either efficacy or safety. The NSAIDs, such as aspirin and ibuprofen, are beneficial and help to reduce swelling, heat and pain. The patient may feel better, but no rebuilding of the tissues has occurred and further degeneration may have actually occurred.

We believe this is the kind of information that you, the athlete, really need to know, and that you want to know about. After all, it's better for you and your health.

**cyberAthlete
chat room**

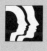 **CYBER INFO SITE**
Treatment vs. Healing

What is the difference between <u>treatment</u> and <u>healing</u>? This is a key question for anyone who truly desires great health. Treatment, in the narrowest sense, is the application of drugs or surgery, the bringing into play of some foreign object, often alien to the body's natural ecology, to stop illness' symptoms—but from the outside, usually not getting at the root of the problem.

Of course, emergencies, such as bacterial pneumonia, require acute <u>treatment</u>. For the lengthening "marathon" of life today, however, we want to focus our attention on promoting healing. Healing stimulates the body's own natural powers and promotes a longer and healthier life. Your body, when all is said and done, is the greatest healing pharmacy. Turning on the healing powers of your own body is key to health. This is especially true for athletes who have suffered injury.

The NSAIDs are beneficial in that they are anti-inflammatories; they stop or slow down inflammation. Hence, they reduce redness, swelling, heat and pain. They probably make the patient feel better quickly, but they do have common side effects. What's more, these agents do not rebuild cartilage. They do not enhance the healing response, either; in fact, they probably retard the healing process. They do not have the excellent safety profile that systemic oral enzymes have. Besides, they are drugs. Systemic oral enzymes are a natural drug-free medicine.

CYBER INSIGHT

Treatment from the outside leaves the body's healing powers untapped. Healing that comes from within taps the body's own powers of regeneration.

The Non-drug European Secret to

How **pain** is usually treated

We face a real dilemma as sports doctors. Our patients want to get back into the action as rapidly as possible. They demand quick pain relief. They come into their doctors' offices and demand prescriptions they truly believe are going to prove to be magic bullets. Even though we know about their complications, particularly the very serious complications associated with the use of corticosteroids, we continue to prescribe these medications. This may be because very often, physicians simply don't know about other safe avenues of treatment such as systemic oral enzymes. At other times, we simply *hope* that the complications will be minimal and, yet, provide much needed pain relief.

The key is *pain*. As doctors, we are attuned to relieving pain. Americans know all about pain. They react strongly to pain. Take American gymnast Kerri Strugg who hit the mat after her memorable vault at the 1996 Olympics in Atlanta, Georgia. "The whole world winced.

CYBER CHAT ROOM
Beyond Pain Relief

Pain is an important sport injury issue, but hopefully not the sole issue. Relieving pain should not be confused with rebuilding and regenerating damaged tissues. This is an especially important distinction for athletes who intend to be champions. We must move beyond pain relief into a world where the body's healing powers are stimulated. That is why we believe systemic oral enzymes are so important. They relieve pain—and turn on the body's healing powers.

Her pain was unmistakable," observe Mary E. O'Brien, M.D. and Donna Hoel in a recent issue of *Postgraduate Medicine*.[2] Yet, we loved her gritting her teeth, sticking out her chin, keeping a stiff upper lip and transcending the pain!

In fact, pain was, and still generally is, considered an essential part of the human experience. Those who bear the greatest pain are accorded the greatest respect, and courage and moral strength continue to be tied up in the ability to withstand pain.[3]

Sport injuries are usually treated with non-steroidal anti-inflammatory drugs (NSAIDs) or analgesics. Examples of NSAIDs are aspirin, diclofenac, and ibuprofen which are quickly effective against pain and relieve the most disturbing symptoms for patients. Other drugs, known as analgesics, are also used for pain relief, including acetaminophen (Tylenol) which has only weak anti-inflammatory properties and is not considered a true NSAID but is effective as an analgesic for mild to moderate pain. There are now nearly 30 pharmaceutical agents classified as NSAIDs. One reason there are so many different brands is that each particular

SPECIAL URGENT COMMUNICATION

Cortisone Medications

The most powerful anti-inflammatory drugs are the cortisone-type medications, or corticosteroids. They may offer complete pain relief and relieve almost all swelling as well. Doctors try to eliminate their serious side effects by giving as low a dose as possible and using injections at the site of inflammation.

However, these drugs should be used only as the very last resort because of their significant long-term complications which include thinning bones (osteoporosis) and fractures, cataracts, glaucoma, high blood pressure, stomach irritation and bleeding, weight gain, frequent infections, and worsening of diabetes mellitus. It is important to note that systemic oral enzymes can help athletes avoid the need for chronic corticosteroid use.

The Non-drug European Secret to

drug works a little differently with individual patients. What's more, their drug interactions and effects on the blood will also differ according to their individual structure.

Most analgesics and NSAIDs can be safely used for two to three days, and many are sold as OTC drugs with reduced recommended dosages. Obviously, instances occur when the use of these drugs is the best course of action. No one is calling into question their value in appropriate situations. However in the case of long-term treatment of athletes' injuries, especially those that tend to be chronic, using these drugs instead of, and without, systemic oral enzymes is due to lack of insight; although these drugs are anti-inflammatories, they do not stimulate healing.

What's more, when these drugs are used for longer periods, virtually all patients suffer complications that can range from micro-bleeding in the gastrointestinal tract to liver or kidney toxicity. It is extremely important when using these medications to follow all label instructions and precautions.

health problems with non-steroidal anti-inflammatory drugs

These medications also may have interactions with other drugs that you may be using. For this reason, if you are using other drugs, you should use them only if you have consulted with your physician. Also of note, athletes over 65, those with ulcers, smokers and especially people on cortisone-type medications may all be advised against using NSAIDs because of the greater risk for complications.

What about aspirin? One of the most commonly used OTC drugs is aspirin, which is commonly recommended for sports injuries and osteoarthritis. It does, in fact, relieve pain and inflammation, is inexpensive, and can also help to prevent heart attacks and strokes. But it must often be used at a very high dose, four to eight grams per day; and, at these higher doses, toxicity often occurs including tinnitus and gastric irritation. We believe it is probably better to use enterically coated aspirin, if you're going to use this pain reliever at all. Better yet, we suggest that you try systemic oral enzymes to address your sports injury or osteoarthritis-related problems, possibly in combination with a glucosamine sulfate preparation that can also help to reduce inflammation.

How **common** **pain drugs** inhibit healing

No doubt, these fast acting drugs relieve pain. Believe it or not, unfortunately, that is not all that they do. They inhibit the repair processes your joints and other tissues desperately require in order to effect their healing. On the other hand, systemic oral enzymes not only relieve pain, they hasten the entire healing process and set the stage for cartilage stabilization, a potentially superior health strategy that all rehabilitating athletes should know about.

As early as 1978 researchers from Italy reported NSAIDs actually inhibit the body's ability to produce cartilage cells. They pointed out that the metabolism of the cartilage (the blue-white tissue at the ends of bones that provides cushioning and joint mobility) may even be impaired and the degenerative process accelerated using these drugs. Non-steroidal anti-inflammatory agents, therefore, should be given only for a short period time, when pain is very severe, they said.

Researchers, writing in *Current Medical Research and Opinion*, noted:

"Most of [the typically prescribed drugs] have proved to reduce the metabolic capacity of the cartilage, and this could lead possibly to an impairment

CYBER INSIGHT

Therapeutic advances have been made in treating sports injuries, but athletes (and physicians) may become frustrated at the apparent lack of breakthrough treatments.

of articular function in the long run. Most of these preparations, moreover, cannot be administered as long as necessary, either because of inconvenience to the patient or because of severe side-effects, usually gastric."[4]

José M. Pujalte, M.D. and co-investigators reported in *Current Medical Research and Opinion* in 1980 that, "In this long run this could result in an even worse condition."[5]

This finding of a poorer state of overall tissue health, after the use of common sports injury drugs, has been verified in many studies published in journals such as *Lancet* and the *Journal of Bone and Joint Surgery*.[6, 7, 8] Preliminary clinical data suggest a method of action by which ibuprofen-type drugs may have a negative effect on joint and tissue health: they adversely affect the body's balance of prostaglandins, a family of fatty acids involved in the body's inflammation processes; apparently, the NSAIDs tip the body's balance in favor of those that allow for subacute inflammation.[9]

How **common pain drugs** inhibit healing

Although NSAIDS reduce the signs and symptoms of redness, swelling and inflammation and bring relief to millions of people, they "do not eliminate underlying disease. ... Failure to provide long-term benefits combined with the high toxicity of most of the disease-modifying agents has prompted a search for more effective treatments."[10]

Drugs used in the treatment of sports injuries and osteoarthritis also have the potential of depleting the blood of another impor-

CYBER INSIGHT

No doubt, these fast acting drugs relieve pain. Believe it or not, unfortunately, that is not all that they do. They inhibit the repair processes your joints and other tissues desperately require in order to effect their healing. On the other hand, systemic oral enzymes not only relieve pain, they hasten the entire healing process and set the state for cartilage stabilization, a potentially superior health strategy that all rehabilitating athletes should know about. In fact, the NSAIDs may inhibit joint healing.

tant nutrient, sulfate, which is necessary to the body's production of specialized cartilage cells called glycosaminoglycans. Indeed, the athlete's body is already not producing enough sulfur-derived glycosaminoglycans when it is suffering from a sports injury. Under the influence of these drugs, the body produces even fewer glycosaminoglycans. Those that are produced tend to be sulfate-depleted and inferior in quality. This results in further joint deterioration, and is intrinsically in opposition to healing.

Yet, because humans have naturally very low serum sulfate levels in their blood, they react extremely sensitively to sulfate depletion.

The very drugs intended to help damage the joint even more by depleting the body of sulfate.

Systemic oral enzymes, on the other hand, while they don't work as fast as these pain killers, seem to actually work better after the first week or two of use, providing a deeper, longer lasting period of pain relief and, of course, stimulating the healing process that results in tissue regeneration.

BOTTOM LINE

• NSAIDs offer quick pain relief, but they do not address the underlying condition and may even hasten the degeneration of tissues.

• Use NSAIDs, if necessary for quick pain relief. Try to avoid their use beyond two or three days.

• After that, try Wobenzym®N systemic oral enzymes in three divided doses of three to five pills daily.

• If you are a long-term user of NSAIDs or other drugs, work with your doctor or health professional to gradually taper their dosage while simultaneously transitioning to Wobenzym®N.

CYBER INFO SITE
If you do use pain killers, be sure not to use them before exercising just to get a better work-out. If you mask pain, you'll never know that you are doing damage. Use pain killers afterwards, if you must, only then to help with pain.

Types of
sports injuries

TWO MAJOR TYPES OF SPORT INJURIES
On a whole there are two main types of sport injuries, overuse injuries and acute injuries.

OVERUSE INJURIES
Overuse injuries are characteristic of an accumulation of repetitive trauma to the tissues of the body. Most activities that cause these injuries involve prolonged repetitive movement of large muscle groups. Sometimes the problem is more mental than physical.

Sports are a great outlet for emotions that build-up in us, but they should not become an obsession, and one area to which athletes must be sensitized is to interactions between mind and body. Chronic use injuries often are a telltale sign of overtraining. If you're overtraining, you won't be as effective an athlete. Athletes of all levels must recognize that they will perform best when they balance training with other important areas of life. Still, the pursuit of excellence requires tireless training, and tennis or pitcher's elbow, shin splints, hip pointers, and other chronic overuse injuries are likely to become part of the elite athlete's life. Systemic oral enzymes are especially beneficial in reducing such chronic inflammation and soreness, allowing for quicker recovery.

ACUTE INJURIES
An acute injury occurs from one incident. These injuries are often seen in contact sports and are thought of as "traditional injuries." Sprains, strains, bruises, dislocations and breaks all fall into this category. There are two sub-types of acute injuries: those to the soft tissues and those to the bones or skeletal injuries.

SOFT TISSUE INJURIES

About 95 percent of sports injuries are due to minor trauma involving soft tissue injuries—sprains, strains (muscle pulls), contusions, bruises, and cuts or abrasions. The patients are often able to take of themselves. A safe and efficient therapy with few adverse effects is all the more mandatory. Systemic oral enzymes are probably the athlete's greatest healing friend when it comes to soft tissue injuries because there is no toxicity and, as a result, the athlete can self-medicate without fear of long-term complications, while achieving both pain relief and stimulating healing.

SPECIAL DATA DELIVERY
Types of Soft Tissue Injuries

• *Sprains. About one-third of all sports injuries are classified as sprains, defined as a partial or complete tear of a ligament, which is the tough band of fibrous connective tissue that connects the ends of bones and stabilizes the joint. Symptoms include the feeling that a joint is "loose" or unstable; an inability to bear weight because of pain; loss of motion; the sound or feeling of a "pop" or "snap" when the injury occurred, and swelling.*

• *Strains. A strain is a <u>partial or complete tear of a muscle</u> or tendon. Muscle tissue is made up of cells that contract and make the body move. A tendon consists of tough connective tissue that attaches muscles to bones.*

• *Contusions. The most common sports injury is a contusion or bruise. Bruises result when a blunt injury causes underlying bleeding in a muscle or other soft tissues. Treatment for soft tissue injuries usually consists of rest, applying ice, wrapping with elastic bandages (compression), and elevating the injured arm, hand, leg or foot. Hematomas, or leakage of blood, may develop.*

• *Spinal cord injuries. Although rare in sports, 10 percent of all spinal injuries occur during sports, primarily diving, surfing and football. Participants in contact sports can minimize the risk of minor neck spinal injuries such as sprains and pinched nerves by doing exercises to strengthen their neck muscles.*

SKELETAL INJURIES

A sudden, violent collision with another player, an accident with sports equipment, or a severe fall can cause skeletal injuries in the athlete, including fractures. Skeletal injuries occur far less frequently than soft tissue injuries.

• Fractures constitute a low five to six percent of all sports injuries. Most of these breaks occur in the arms and legs. Rarely is the spine or skull fractured.

• Stress fractures occur frequently because of continuing overuse of a joint. The main symptom of a stress fracture is pain. The most frequent places stress fractures occur are the tibia (the larger leg bone below the knee), fibula (the outer and thinner leg bone below the knee), and foot.

When skeletal injuries occur and inflammation ensues or surgery is required, systemic oral enzymes are especially powerful allies.

**types of
sports
injuries**

How **systemic oral enzymes accelerate healing**
of sports injuries

"Rubor et tumor cum calore et dolore." In the first century A.D., Celsus pretty much summed up the classical signs of inflammation: redness, swelling, heat and pain. He neglected to mention loss of function, a seat on the sidelines, and the intense frustration that all benched athletes experience. After an injury, a sequence of events is set in motion at the cellular and biochemical levels that results in resolution. In general, the healing response can be divided into three major portions or phases: inflammation, repair, and remodeling. In each of these phases Wobenzym®N can help to heal the body quickly and safely.

INFLAMMATION

Immediately after injury, acute vasoconstriction lasts for a few minutes until a number of chemical mediators exert their effects. One such chemical mediator is called bradykinin. It is a hormone that dilates blood vessels and increases capillary permeability, allowing for the transport of additional healing agents. Meanwhile, leukocytes initiate movement of additional white blood cells to the injured area to start getting rid of damaged and dying tissue and prevent infection. This increased presence of white blood cells causes release of massive amounts of additional proinflammatory mediators and leads to expression of the clinical signs of inflammation. Inflammation induces edema.

Unless the healing process is optimized, subacute inflammation may linger for weeks or months.

The Non-drug European Secret to

Systemic oral enzymes allow the body to enter the repair and remodeling phases of sports injuries more quickly.

REPAIR
The second phase of healing sports injuries is the repair phase. The repair phase is characterized by cell growth and production of extracellular matrix (collagen and proteoglycans). During this phase, enzymes help by reducing scarring or sclerosis.

REMODELING
The third phase is called remodeling (maturation) which occurs about 14 days after the injury. Collagen activity approaches normal turnover. Systemic oral enzymes enable the body to enter the remodeling phase more quickly, as shown in more than one dozen

how **systemic oral enzymes accelerate healing** of sports injuries

SPECIAL DATA DELIVERY
How Enzymes Work
Enzyme mixtures work by hindering or mitigating excessive inflammatory reactions. They have been shown to help:
- *Break down proteins in the blood that cause inflammation by facilitating their removal via the blood stream and lymphatic system.*
- *Remove "fibrin," the clotting material that prolongs inflammation.*
- *Clear up edema (excess water) in the areas of inflammation.*
- *Counteract chronic, recurrent subacute inflammation, a primary cause of chronic degenerative joint diseases.*
- *Prevent formation of excess scar tissue.*
- *Wobenzym®N, the world's leading enzyme formula, contains rutin, a bioflavonoid, which normalizes damaged vessels and helps to encourage transportation of the body's own defensive substances required for healing to the site of inflammation.*

studies in which injured athletes given Wobenzym®N have been able to return to action much more quickly than athletes given typical NSAIDs or placebo.

BOTTOM LINE

Most sport injuries, no matter how serious, involve redness, inflammation, swelling, and pain and require both immediate and long-term treatment. Systemic oral enzymes are superior for treatment because they directly influence each of the phases of sports injuries without complications associated with the NSAID class of drugs that are typically prescribed.

CYBER INFO SITE
What are Enzymes?

Technically, an enzyme is any of various types of proteins which act as catalysts to speed up the body's biochemical processes. Without enzymes, life cannot exist. Enzymes are the tools that create life. All living material contains enzymes. Enzymes control the chemical reactions of all organisms, big or small. Enzymes act as catalysts. They work in a "lock and key" manner to change the structure of molecules by splitting them or combining them.

More than three thousand different enzymes have been identified in the human body. They build new proteins, cells, tissues, and organs. Enzymes such as bromelain and papain are derived from plants, particularly pineapples and papayas. Other enzymes, such as amylase and lipase, are derived from bacteria; while others, including trypsin, chymotrypsin and pancreatin are taken from animals, usually porcine sources.

The leading research into enzymes has been conducted by doctors and scientists associated with Mucos Pharma GmbH & Co, of Germany which produces Wobenzym®N, a formula that is considered to be one of the leading enzyme products in the world.

The Non-drug European Secret to

Studies that validate **enzymes** for **sports injuries**

M any European clinical trials have shown just how effective Wobenzyn®N can be for anyone suffering inflammation from sports and athletic injuries.

• In 1979 Wobenzym®N was tested on 45 patients who had sustained sports injuries. Doses ranging from three to ten coated tablets were given. Substantial improvement was seen.[11]

• In a second study, similar good results were obtained for 38 of 56 patients with typical sports injuries who responded "very well." Eight other athletes responded "well" with Wobenzym®N tablets.[12]

• In a double-blind, randomized parallel group study, doctors looked at the effectiveness and tolerance of Wobenzym®N in soft-tissue injuries sustained in athletes.[13] The study included 44 patients with various types of injury. Twenty-two patients each took either Wobenzym®N or place-

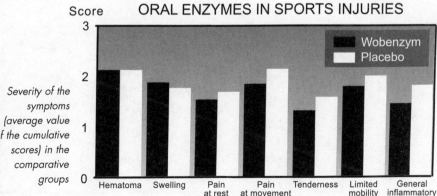

ORAL ENZYMES IN SPORTS INJURIES

Score — Severity of the symptoms (average value of the cumulative scores) in the comparative groups

Wobenzym / Placebo

Hematoma, Swelling, Pain at rest, Pain at movement, Tenderness, Limited mobility, General inflammatory reaction

bo three times daily. The median duration of therapy in both groups was 11 days. The lessening of pain and in the diameter of their hematomas (blood clots) were taken as the primary criteria for statistical evaluation. The results of the study provide impressive evidence that pain and hematomas due to injury can be reduced significantly and more rapidly with Wobenzym®N. The advantage of enzyme therapy was reflected in the reduced need for analgesics and the earlier mobilization in the group taking the preparation. As a result, the rate of absence due to injury in this study was substantially shorter.

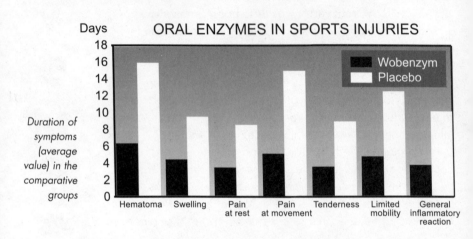

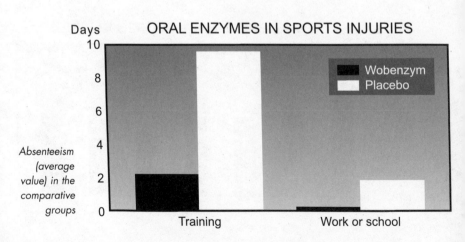

The Non-drug European Secret to

- Perhaps the most physically punishing sport in the world today is boxing. It is with boxers that enzymes have proven to be more than a match for inflammation and pain. In one study, published in *The Practitioner*, enzymes were shown to significantly reduce injuries such as cuts, broken vessels, bruising, and sprains when used prior to entering the ring.[14]

- So effective are enzymes, in fact, that the American Boxing Association stipulates that athletes should take enzyme preparations a few days before a fight in order to subdue the inflammation caused by trauma, and to accelerate healing.[15, 16]

- Similar excellent findings were reported in *The Practitioner* for British soccer players.[17] Among soccer players, enzyme users missed fewer games and had quicker recovery from soft tissue injuries such as bruises and hematomas. Leakage of blood from bruised vessels into body cavities (effusions) was also minimized.

- Further good results were found when enzymes were used for both prevention and for stimulating quicker healing among Germany's Olympic martial arts competitors.

studies that validate enzymes for sports injuries

SPECIAL DATA DELIVERY

Why Choose Wobenzym® N?

It is important to note that virtually all of the sport injury studies done on enzymes were sponsored by Mucos Pharma GmbH, of Germany, producer of the world famous Wobenzyn®N systemic oral enzyme formula. Because of many factors most athletes are not aware of but that the Mucos scientists are, these studies do not apply to other enzyme formulas, and athletes who expect the results reported herein should use the Wobenzym®N formula. For example, injured tissue has a different pH than healthy tissue. Yet, enzymes lose their potency within the body at different levels of pH. The Wobenzyn®N formula is manufactured to be biochemically active and body ready at pH levels found in injured tissues.

Those patients suffering hematomas, swelling, pain, tenderness and impaired mobility experienced much greater improvement in all parameters compared to those athletes not receiving the Wobenzym®N systemic oral enzyme mixture.

• Finally, when the Wobenzym®N enzyme mixture was given to members of the German National Ice Hockey League, it was found that injured players were able to return to competition more rapidly.[18]

• Sprained ankles are one of the most common sports injuries. In one placebo-controlled study, 22 of 44 patients with sprained ankles received Wobenzym®N for a period of 10 days. Quite

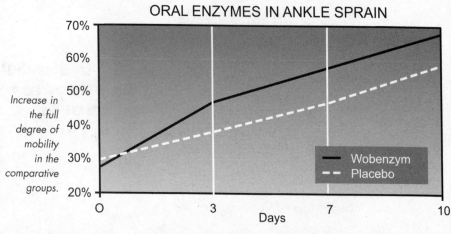

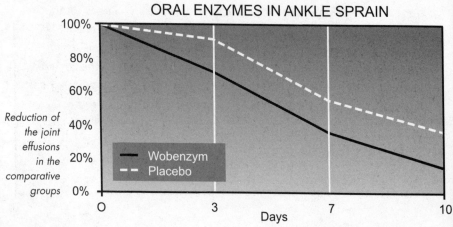

CYBER CHAT
Professionals Discuss Using Enzymes

"The studies that support Wobenzym®N are solid. They have been published in a wide range of peer-reviewed journals. The bottom line is that enzyme therapy is safe and as effective as the use of NSAIDs but without the long-term side effects," notes Raul Ahumada, M.D. "If you desire the very best therapy for sports injuries, Wobenzym®N is essential. I personally think enzyme mixtures, particularly Wobenzym®N, are an extremely important part of sports medicine and recommend them to all of my patients who are suffering inflammatory disorders."

"Having thoroughly researched enzymes, including publishing my doctoral dissertation on enzymes, I highly recommend their use for all types of traumas, including sports injuries," says Albert Lind, M.D. "Enzymes enable sports practitioners to safely and effectively stimulate the healing process in their patients while relieving soreness and inflammation."

studies that validate **enzymes** for **sports injuries**

"Enzymes play an important role in healing sports injuries by mediating the inflammatory process, enhancing and hastening the removal of fibrin and other clotting and sclerosing factors," says Rudolf Kunze, Ph.D.

ORAL ENZYMES IN ANKLE SPRAIN

Reduction of the pain on movement in the comparative groups

100%
80%
60%
40%
20%
0%

— Wobenzym
-- Placebo

O 3 7 10

Days

apart from markedly reduced swelling and pain, mobility of the injured joint was restored substantially more rapidly in patients taking the enzyme mixture.[19] The duration of disability was shortened significantly. Additional studies validate the great benefits athletes with sprained ankles receive from systemic oral enzymes.[20, 21]

• More than 20 additional studies have further confirmed that enzymes stimulate faster healing and reduced swelling, immobility, inflammation, tenderness, and pain along with improved recovery time.[22]

• Tony Cichoke, D.C., a leading sports medicine doctor and enzyme expert, notes that for promoting healing due to sports injuries, "Some feel that enzyme mixtures are superior [to many medically prescribed drugs] because of their comparable efficacy, but minimal side effects."

ENZYMES AND SURGERY FOR THE ATHLETE

Surgeons and sports physicians know that surgical fracture operations require optimal preparation, which always includes the rapid and efficient treatment of post-traumatic edema and hematoma. The great benefits from systemic oral enzyme therapy have been repeatedly verified in placebo-controlled, double-blind studies.

•Ankle and knee surgery are among the most common surgeries among athletes. With the goal of verifying the anti-edema effects of Wobenzym®N, doctors performed an open, prospective, randomized clinical study with parallel groups. The efficacy and tolerability of Wobenzym®N was compared to another natural powerful medicine, aescin, derived from horse chestnut seed extract.[23] Fifty-nine patients with injuries of the knees or ankle joints requiring surgical treatment took part in this study. Depending on the group assignment, 29 patients received five Wobenzym®N tablets three times daily and 30 patients two tablets of aescin three times daily. The duration of the therapy was ten days. The groups were matched with respect to age, sex, edema, joint effusion, inflammation, pain, ability to raise the extended leg and their cumulative scores. The circumference of the joint and the pain score were established as the main inflammatory criteria for the study. Additional criteria

The Non-drug European Secret to

CYBER INFO SITE

How to Use Enzymes
for Athletes and Sports Injuries

- *Prefer combination formulas (e.g., Wobenzym N).*
- *Prevention is preferred. Athletes should take enzymes prior to physically demanding events.*
- *Take enzymes on an empty stomach, at least 45 minutes before a meal, with water or juice.*
- *In case of acute injuries, begin taking as soon as possible. Ingest 5 to 10 tablets three to five times daily when injured.*
- *Take a daily maintenance dose of five tablets two to three times daily.*
- *If you are already using NSAIDs such as ibuprofen, gradually taper your dose over a several week period; if necessary, consult a health professional.*
- *Enzymes are slower acting than drugs such as ibuprofen. For quick relief, use OTC or prescription painkillers for the first few days. But over several days to several weeks, the pain-relieving capabilities of Webenzym®N will outperform that of the NSAIDs and without toxicity.*

SPORTS INJURIES ENZYMES WORK ON...

Acute, traumatic injuries
Bruises, hematomas, contusions,
Sprains, Strains, muscle pulls
Lacerations, abrasions, wounds
Fractures

Surgical procedures of all kinds

Sciatica and acute lower back pain

Chronic joint conditions
Rheumatoid arthritis
Osteoarthritis
Bursitis
Tendinitis

were further clinical and laboratory data and need for other analgesics. All in all, the joint swelling in the enzyme group diminished to a greater extent. The substantial reduction in the swelling of the ankle joint was statistically significant. The drop in pain scores was nearly equal for both groups, although it must be mentioned that the aescin group required substantially greater amounts of analgesics. No statistically significant differences were seen between the therapy with Wobenzym®N versus escin for any of the other criteria examined.

• In a study of 120 patients requiring operative fracture reduction, both study groups of 60 patients each began by taking ten tablets of Wobenzym®N or placebo three times daily five days prior to surgery.[24] Relief of pain and reduction of edema were substantially better in the Wobenzym®N group after only three days post-surgery. This significant difference between the two comparative groups continued postoperatively. It should also be emphasized that the patients on oral enzymes were able to leave the hospital earlier as well, as shown in multiple studies.[25]

• Another form of knee surgery is meniscectomy. A double-blind study was conducted on 80 patients who had to undergo total meniscectomy. Whereas 40 patients were treated with enzymes postoperatively, the other 40 test subjects received a placebo. The patients were instructed to take 30 coated tablets of Wobenzym®N or the dummy pills daily. The duration of therapy was seven days for both groups. Edema, swelling, inflammation, pain and limitation of mobility were examined to evaluate the efficiency of the therapy. The symptom complex responded significantly better to the postoperative administration of Wobenzym®N. It was possible to mobilize the patients earlier to restore the mobility of the knee joint.[26, 27]

• Arthroscopic operations of the knee joint have become well established in recent years, the technique being superior to open surgery. It therefore appeared relevant to examine the efficacy of Wobenzym®N especially in arthroscopic meniscectomies. In a further clinical, double-blind study, with 80 patients each in the enzyme preparation and placebo groups, the test subjects received either Wobenzym®N or placebo for an average of nine days.[28] The patient groups were matched with respect to

age, sex, height, weight and severity of the injury. The statistical evaluation was based on a defined cumulative score consisting of data on edema, pain and limitation of mobility. Additionally assessed was improvement of further clinical parameters and the duration of the hospital stay. The cumulative scores of the Wobenzym®N group dropped significantly faster and more substantially, confirming clinical effectiveness.

THE BOTTOM LINE
Clearly, Wobenzym N can get you back into the action quickly and safely. We want you to be a champion. A drug-free champion. The Wobenzym N systemic oral enzyme formula is one of the most important tools that you can use to be a total champion.

studies that validate **enzymes** for **sports injuries**

A final word to All
Athletes

In this report, we've told you about one of the most powerful drug-free healing systems now available to athletes who are engaged in the quest for excellence. The Wobenzym®N systemic oral enzyme formula is for all athletes, of all ages, and of all levels. We've told you about the phases of sports injuries and how enzymes work, and we've provided you more than one-dozen key studies to prove to you that they work. Systemic oral enzymes are the drug-free way of healing your injuries.

If you're an athlete or simply someone who wants to stay in great shape and enhance your health with daily exercise, supplementing your diet with an enzyme mixture is important for relieving chronic inflammation and soreness. Furthermore, enzymes have many other important health benefits, including mild anti-clotting effects (which may reduce risk of heart disease) and enhancing digestion and immunity.

As consumer advocates, however, we must stress that virtually all of the studies performed on enzymes and sports injuries were done with the Wobenzym®N formula. Other companies have used these studies to support their enzyme formulas, but these cannot produce the same results as Wobenzym®N. There are key manufacturing practices utilized by Mucos Pharma to produce Wobenzym®N, including insuring stability, and proper pH activity of the actual enzymes. Wobenzym®N is the only enzyme product in America measured in F.I.P. units, the international standard of measurement for actual enzyme activity. While not all, many enzyme products are measured only by their contents and cannot guarantee the actual activity of the enzymes.

Wobenzym®N is the most popular non-aspirin over-the-counter preparation in Germany and is the most thoroughly researched enzyme mixture available worldwide. Wobenzym®N contains five potent enzymes including pancreatin,

trypsin, chymotrypsin, bromelain, and papain, as well as the bioflavonoid rutin. Enzymes are not as fast acting as typical NSAIDs such as ibuprofen, but over the long run, they are much safer and more effective. We recommend Wobenzym®N as a truly safe and natural pathway to healing sports injuries and other inflammatory conditions.

STATE GAMES RECOVERY FORMULA (ALSO KNOWN AS SPORTS ZZIP™)

There is one additional formula that we want to tell you about. The State Games Recovery Formula (also known as Sports Zzip™) was created by Naturally Vitamins especially for drug-free athletes competing in the prestigious State Games. This formula complements the powers of Wobenzym N and was created to naturally improve performance, endurance, and recovery during periods of intensive training and competition.

Its combination of herbs and nutrients is especially attuned to the needs of the intensively training athlete. The formula contains Yunamite pine pollen, one of the most unique pollens that we have ever seen used in human nutrition. Only recently discovered by Western scientists, Yunamite pine pollen is used in Chinese medicine as a fantastic energizer. Its properties are important to the competitive athlete, as it improves lipid conversion into blood sugar; lowers post-workout lactate levels; and greatly increases the activity of the antioxidant superoxide dismutase.

a final word to
All Athletes

What is the meaning of the Chinese word "seng"? Our best English translation is *essence*. Siberian ginseng is one of the most wonderfully documented endurance herbs. This estimable herb's root is shaped like a human and it is said to embody the earth's essence, the crystallization of all of the complexities and energy of the earth's soils. We now know that the herb is, in fact, an endocrine enhancer, particularly affecting and balancing adrenal secretions, according to a 1986 particle in *Planta Medica*. In a 1996 study in *Phytotherapy Research*, a preparation of Asian ginseng, together with vitamins and minerals, was tested among 232 people who complained of daily fatigue. Those taking the supplement had improved energy, better concentration, and less anxiety compared to those who took only the placebo. Siberian ginseng has also been shown to be helpful in reducing feelings of fatigue among dia-

betics and helping the body to utilize sugar, increasing insulin sensitivity, according to a 1995 article in *Diabetes Care*.

The State Games Recovery Formula also provides potassium and magnesium to restore the body's electrolyte balance, maintain regular heartbeat and prevent muscle spasms and cramping. Its vitamin B-12 content helps to build-up red blood cells and carry oxygen while its small amount of cocoa provides phytochemicals that strengthen heartbeat, relax smooth muscle, lessen resistance to blood flow, and assist in stronger contraction of striated muscle.

See our resources section for information on obtaining your State Games Recovery Formula (also known as Sports Zzip).

The Non-drug European Secret to

How to purchase
Wobenzym®N
and the State Games
Endurance and Recovery Formulas
(e.g. Sports Zzip)

Fortunately, Wobenzym®N is available in the United States at better health food stores and pharmacies nationwide. For more information or for a store nearest you, contact Naturally Vitamins at 14851 North Scottsdale Road, Scottsdale, Arizona 85254 or call (800) 899-4499. They can be reached via cyberspace and the World Wide Web at www.naturallyvitamins.com, www.defend-yourhealth.com or www.wobenzym.com. Naturally Vitamins is also the source for the State Games Endurance and Recovery Formula (the Sports Zzip formula).

References

1 "Anti-Inflammatory Drug Wins Approval from FDA." *The Wall Street Journal.* July 7, 1997: B7.

2 O'Brien, M.E. & Hoel, D. "Overpowering pain. A serious problem comes out of the closet." *Postgraduate Medicine,* October1997: 4-10.

3 Ibid.

4 Crolle, G. & D'Este, E. "Glucosamine sulfate for the management of arthrosis: a controlled clinical investigation." *Current Medical Research and Opinion,* 1980; 7(2): 104-114.

5 Pujalte, J.M., et al. "Double-blind clinical evaluation of oral glucosamine sulphate in the basic treatment of osteoarthrosis." *Current Medical Research and Opinion,* 1980; 7(2): 110-114.

6 Newman, N.M. & Ling, R.S.M. "Acetabular bone destruction related to non-steroidal anti-inflammatory drugs." *Lancet,* 1985; ii: 11-13

7 Solomon, L. "Drug induced arthropathy and necrosis of the femoral head." *Journal of Bone and Joint Surgery,* 1973; 55B: 246-251.

8 Ronningen, H. & Langeland, N. "Indomethacin treatment in osteoarthritis of the hip joint." *Acta Orthop Scand,* 1979; 50: 169-174.

9 Müller-Faßender, H., et al. "Glucosamine sulfate compared to ibuprofen in osteoarthritis of the knee." *Osteoarthritis and Cartilage,* 1994; 2: 61-69.

10 Spencer-Green, G. "Drug treatment of arthritis. Update on conventional and less conventional methods." *Postgraduate Medicine,* 1993; 93(7): 129-140.

11 Müller-Hepburn, W. "Anwendung von enzymen in der sportmedizin." *Forum d. Prakt. Arztes,* 1979, 18.

12 Ibid.

13 Baumüller, M. "Der einsatz von hydrolytischen enzymen bei stumpfen weichteilverletzungen und sprunggelenksdistorsionen." *Allgemeinmedizin,* 1990; 19: 178.

[14] Blonstein, J.L. "Oral enzyme tablets in the treatment of boxing injuries." *The Practitioner,* April 1967, 198: 547.

[15] Ibid.

[16] Hiss, W.F. "Enzyme in der sport- und unfallmedizin." *Continuing Education Seminars,* 1979.

[17] Boyne, P.S. & Medhurt, H. "Oral anti-inflammatory enzyme therapy in injuries in professional footballers." *The Practitioner,* April 1967, 198: 543.

[18] Wörschhauser, S. "Konservative therapie der sportverletungen. Enzympräparate für therapie und prophylaxe." *Allgemeinmedizin,* 1990; 19: 173.

[19] Baumüller, M. "Enzyme zur wiederherstellung nach sprunggelenkdistorsionen." *Z. Allg. Med.,* 1992; 68: 61.

[20] Ibid.

[21] Baumüller, M. "Therapy of ankle joint distortions with hydrolytic enzymes—results from a double blind clinical trial." In: G.P.H. Hermans, W.L. Mosterd (eds.): *Sports, Medicine and Health. Excerpta Medica.* Amsterdam, New York, Oxford, 1990: 1137.

references

[22] Bucci, L.R. *Nutrition Applied to Injury Rehabilitation and Sports Medicine,* Boca Raton: CRC Press, 1995. p. 170.

[23] Schwinger. "Wobenzym® bei der bedhandlung von knie- und sprunggelenksoperationen." Publication in preparation.

[24] Rahn, H.-D. & Kilic, M."Die wirksamkeit hydrolytischer enzyme in der traumatologie. Ergebnise nach 2 prospektiven randomisierten doppelblindstudien." *Allgemeinarzt,* 1990; 19: 178.

[25] Rahn, H.-D. "Efficacy of hydrolytic enzymes in surgery." In: G.P.H. Hermans, W.L. Mosterd (ed.): *Sports Medicine and Health,* Amsterdam-NewYork-Oxford: Excerpta Medica, 1990: 1134.

[26] Rahn, H.-D., Kilic, M. Op. Cit.

[27] Rahn, H.-D. "Enzyme verkürzen rekonvaleszenz." In: *Medizinische Enzym-Forschungsgesellschaft.* E.V. (eds.): *Systemische Enzymtherapie,* 13th Symposium, Lindau, 1990.

[28] Rahn, H.-D. "Wobenzym® begleitend bei arthroskopischer meniskektomie." Publication in preparation.

About the Authors

MICHAEL W. LOES, M.D., M.D.(H.)

Michael W. Loes, M.D., M.D.(H.), is currently the director of the Arizona Pain Institute, a division of the University of Arizona's Integrative Program in anesthesiology. He is board certified in internal medicine with subspecialty board certifications in pain medicine and management, addictionology, acupuncture, clinical hypnosis and homeopathy. He is a faculty assistant professor at the University of Arizona Health Science Center, Tucson, and a faculty consultant to the Mayo Clinic Scottsdale Pain Center. He has helped hundreds of athletes and sports injury patients over the years to regain their health by enhancing their bodies' healing powers, using many of the techniques detailed in this book, including Wobenzym N. Dr. Loes is co-author of *Arthritis: The Doctors' Cure* (Keats Publishing 1998).

DAVID STEINMAN

David Steinman is a resident of Topanga, California. He is author or co-author of *Diet for a Poisoned Planet* (Crown 1990, Ballantine 1992), *The Safe Shopper's Bible* (Macmillan 1995), *Living Healthy in a Toxic World* (Perigee 1996), *The Breast Cancer Prevention Program* (Macmillan 1997, 1998), *Arthritis: The Doctors' Cure* (Keats Publishing 1998) and the forthcoming novel, *Bloodlands*. He is chairman of Citizens for Health and served two years on a committee of the National Academy of Sciences where he co-authored *Seafood Safety* (National Academy Press, 1991). He is publisher of *The Doctors' Prescription for Healthy Living*, one of the largest circulation health letters in the United States today. Steinman is a member of the teaching faculty at National University and the University of Phoenix. He has won awards from the California Newspaper Publishers' Association, Sierra Club, and Society of Journalists' Best of the West. He is married to the artist Terri Steinman and they have one son.